Want to Say I am Bullshit

By

S.B. Nozaz

Copyright © 2016 by S.B. Nozaz

All rights reserved worldwide. No part of this publication may be reproduced or distributed in any form or by any means, mechanical, electronic or stored in a retrieval or database system, without written permission from the copyright holder.

BITCH

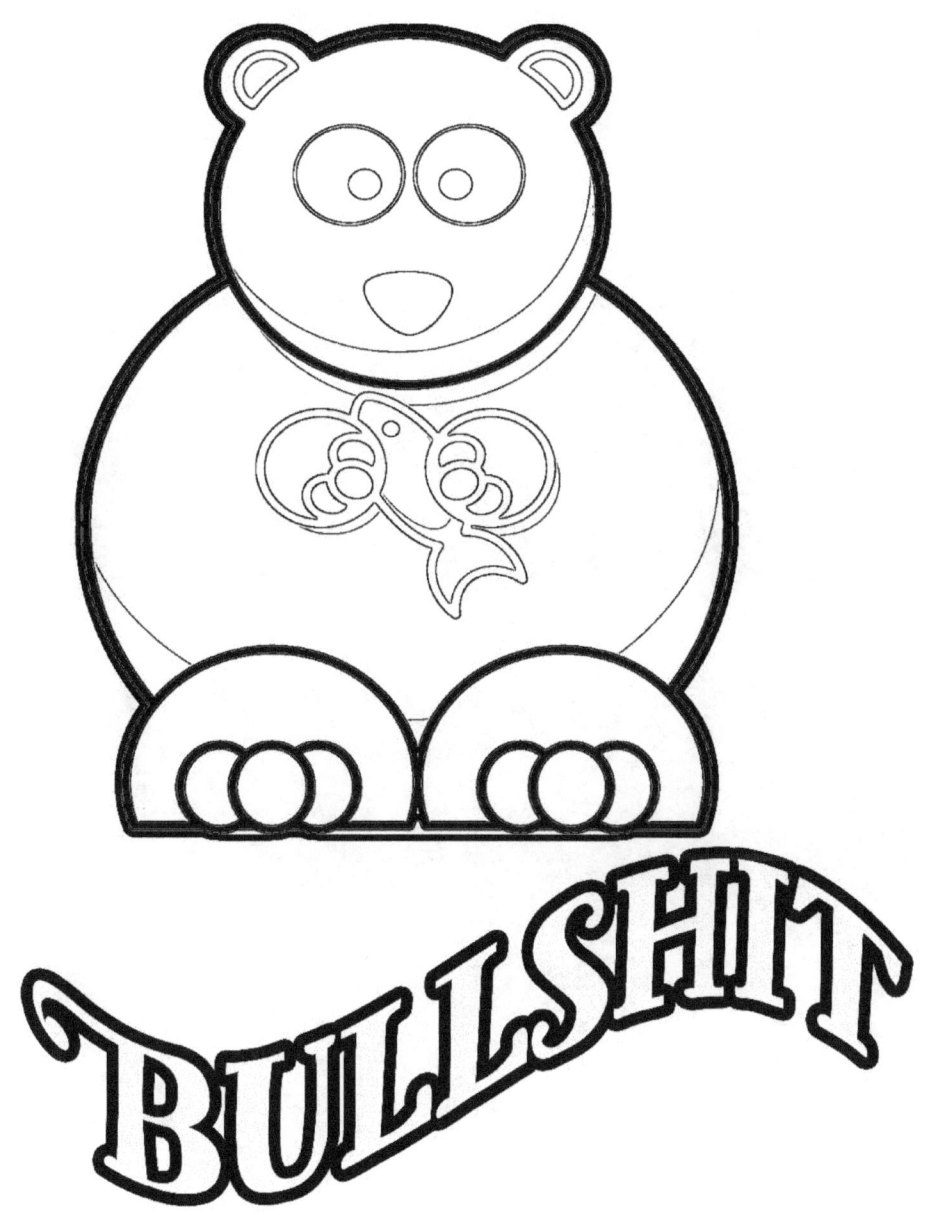

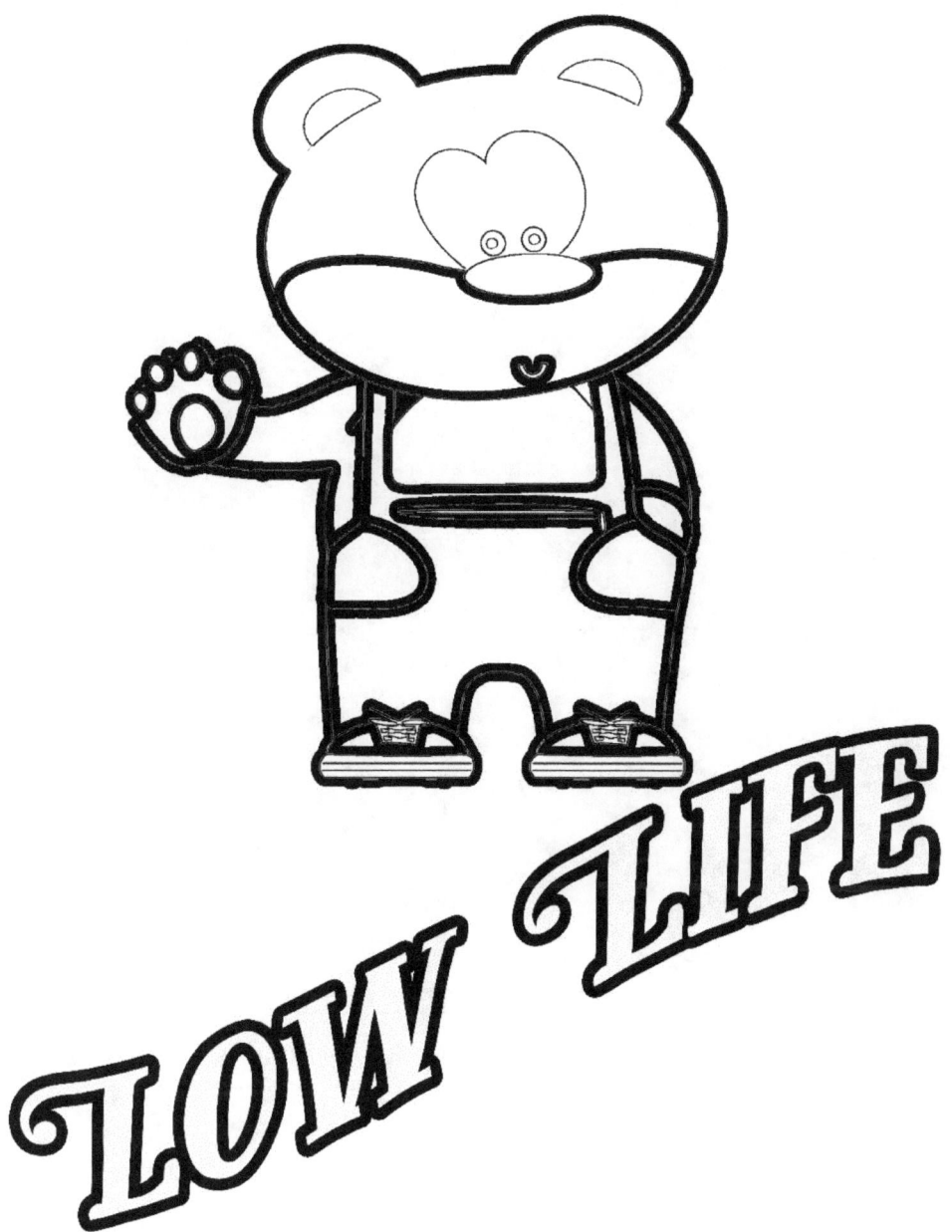

HOLY SHIT

Note

www.ingramcontent.com/pod-product-compliance
Lightning Source LLC
Chambersburg PA
CBHW080639190526
45169CB00009B/3430